MARNIE THE DOG

MARNIE THE DOG
I'M A BOOK

**GRAND
CENTRAL**
PUBLISHING

New York Boston

Grand Central Publishing
Hachette Book Group
1290 Avenue of the Americas
New York, NY 10104

www.HachetteBookGroup.com

Printed in the United States of America

PHX

First edition: October 2015

10 9 8 7 6 5 4 3 2 1

Grand Central Publishing is a division of Hachette Book Group, Inc. The Grand Central Publishing name and logo is a trademark of Hachette Book Group, Inc.

The Hachette Speakers Bureau provides a wide range of authors for speaking events. To find out more, go to www.hachettespeakersbureau.com or call (866) 376-6591.

The publisher is not responsible for websites (or their content) that are not owned by the publisher.

ISBN: 978-1-4555-3832-4
LCCN: 2015944909

Marnie dedicates this book to delicious treats, without whom none of this would be possible, and to anyone who has adopted a homeless animal.

CONTENTS

INTRODUCTION

As someone who previously neither "owned a pet" nor exhibited any potential for above-average social media skills, this is a funny position to be in, though it is funny regardless. Adopting an elderly dog from a shelter who would go on to have millions of fans is not a chapter I could have ever envisioned, much less a book.

I just wanted a dog who was hopefully kind of cute, not necessarily the cutest ever, who would keep me company in my lonely life in a Manhattan shoebox. Instead of swiping for creepy dates, I browsed for homeless dogs, which is how I found Marnie—there were two photos of her on PetFinder.com: in one, she was looking straight ahead at the camera, gazing right at me. In the other, taken a moment later, she averted her eyes, as if she had full comprehension of what a camera does, and why the photo was being taken. This dog seemed like she had some kind of cosmic understanding of the world. Her tongue subtly poked out of the side of her mouth. There was no text. My new mission was to figure out how to get this dog.

But there was no demand for Marnie. She was ten years old and was spending a fourth month in a decrepit shelter when I took the day off work to take a train up to Connecticut to see her. It was the dead of winter, and outside the shelter was a row of cages housing large dogs barking desperately—this

place did not seem quite right. I stepped into the office, which was just an extremely smelly kitchen. I had basically just entered into a real-life Sarah McLachlan "In the Arms of an Angel" ASPCA commercial.

The dog was a hot mess. She was filthy. One of her eyes was gray, and I was told she would never see from it again. She had been found roaming the streets alone, smelly and matted. Her name on the paperwork was Stinky, which really says a lot considering the state of the shelter.

At that point, I didn't so much as actively choose to adopt Stinky as much as I passively went along with it. Unprompted, the shelter owner whipped out the adoption paperwork and showed me where to sign. In a panicked state of consciousness, I became the committed caretaker of Stinky, like marrying a probably nice but half-blind stranger who was also maybe about to die. I got back on the train to NYC with Stinky. A businessman boarded, looked at her face, and quipped, "Ooh, ferocious." I took her straight to PetSmart for a desperately needed bath, and then I took her home.

For the first month I bought poop bags three rolls at a time. The thought of having a substantial amount of surplus poop bags if she passed away seemed like it would be too depressing. Her head was tilted to the left and she kept walking in left circles only, never to the right, and the vet suggested it was possible she had brain cancer. Whenever she ate, she would have a sneezing fit afterward, and she was also diagnosed with the intestinal worm giardia. Thankfully she did not have brain cancer—turned out the head tilt was a residual effect of a brief illness called vestibular syndrome. The rest was solved through antibiotics and dental surgery.

She had to have fourteen decaying teeth removed. That evening, about ten days after

the adoption, I picked her up from the vet, and when the door opened, she came happily running toward me, tongue wagging. It was the first time I felt like this dog and I were an official team. "I love you!" I told her. I felt weird, realizing what I had just said, but then I said it again and it felt right. I began to say it a lot. We grew close quickly, and at Marnie's insistence, I would bring her out with me frequently.

The most unexpected part of Marnie's recovery, for me, was noticing that her once gray eye was clearing up. It was so gradual, I hadn't even noticed it happening; but a few months into our life together, I went back and looked at old photos and realized her eye was healing.

"Can I borrow your dog and make a million dollars on YouTube?" a friend wrote on my Facebook page. "This dog could be Internet famous." "Does your dog have an Instagram?" "This is the cutest dog ever."

I didn't think much of all of these comments I was receiving. It's the type of thing you say to anyone with a cute or funny-looking dog. How do you even actually make a dog famous? The idea that Marnie would somehow be more worthy of clicks than the other hundreds of thousands of cute dogs on the Internet seemed like a delusional, self-centered idea. Of course I thought Marnie was the most adorable dog ever, but I figured I had fallen into the cliché of thinking your child or pet is "the best." *Okay, fine, whatever, I will put her on the Internet.* I made an Instagram page for her, @MarnietheDog, uploaded four photos, hashtagged them #dog #dogsofinstagram #shihtzu. I got three followers. *This is stupid*, I concluded, then gave up. It would be nine months before I posted another photo.

I became "funemployed" after my web series for MTV ended, and I didn't want to get another job where I couldn't bring Marnie

with me. Marnie is not a demanding dog, but the one thing she asks is not to be left alone. I had snuck Marnie into the offices at MTV many times, especially when I had late-night editing sessions, but one day a security guard tapped me on the shoulder in my cubicle and said, "Excuse me, miss, uh, do you have a dog?" Marnie was fired from Viacom, and three months later I'd be gone, too.

I needed to find a job where we could stay together, but I didn't know what to do, so I basically did nothing and lived off my dwindling savings. For months Marnie and I would sleep in, go for a walk, then we'd go hang out with friends at night (Marnie's hearing is less sensitive than a human's; she doesn't mind noise). One night out, unbeknownst to me, someone posted a photo of Marnie and tagged her stagnant Instagram account, and suddenly we had two hundred followers instead of three. I literally had nothing better to do, so shortly thereafter, on Valentine's Day 2014, I posted a new photo to Marnie's Instagram account. It wasn't long before I became addicted to the relatively swift pace of the incoming likes and follows from people who were also appreciating the joys of Marnie.

Two months later, she was featured on Buzzfeed. I was walking down the street the next day when a woman stopped me. "Excuse me, is that Marnie?" She asked for a photo. I couldn't believe it. This seemingly isolated incident occurred again a week later. "That dog is insta-famous!" the person said. And again. A succession of prominent features rolled in on Reddit, Vine, and Tumblr, and a YouTube video of Marnie walking around on one of our many trips to the local pharmacy went viral, landing on *Good Morning America* and all over the place.

Within a year on Instagram, we hit one million followers. Walking around outside with Marnie now is like walking around with

a celebrity, and the strangeness of it all is not lost on either of us. "Imagine if Marnie knew how famous she is," people say. I think she knows. Marnie lived eleven years of her life not being a celebrity. She knows what cameras are. She knows her name. She knows that when people walking down the street scream her name in excitement that this is different than those eleven years before. While there have been moments early on when I questioned whether allowing Marnie in the limelight was a good choice—because "stage mom" is not a very well-regarded career path—she is beyond happy with her life, and most days are just normal days filled with leisurely walks and constant companionship. I never have to leave Marnie for work since I have thankfully been able to turn this into a job.

By the time this book is published, Marnie will be thirteen years old. I hope we have many more years together, but I don't take it for granted and I try to make the most of each day with her. I feel grateful to live in a world where such wonderful living creatures are a real thing, and extra lucky that I get to share my life with one. In the pages that follow I hoped to capture Marnie's wonderful spirit and the love she has for life. People say adopted dogs make the most loving and grateful pets, and I would say senior adopted dogs are even more wonderful. Marnie knows how lucky she is, but, of course, the feeling is mutual.

—Shirley Braha

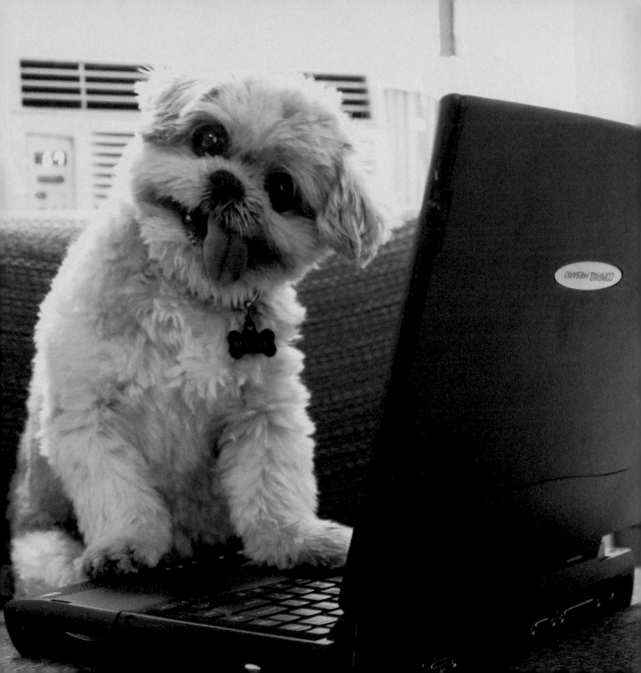

OTAY HERE'S MY BOOK

Hi it's me Marnie.
I am a 13 year old lady. I'm also
a dog haha. I live in NYC.

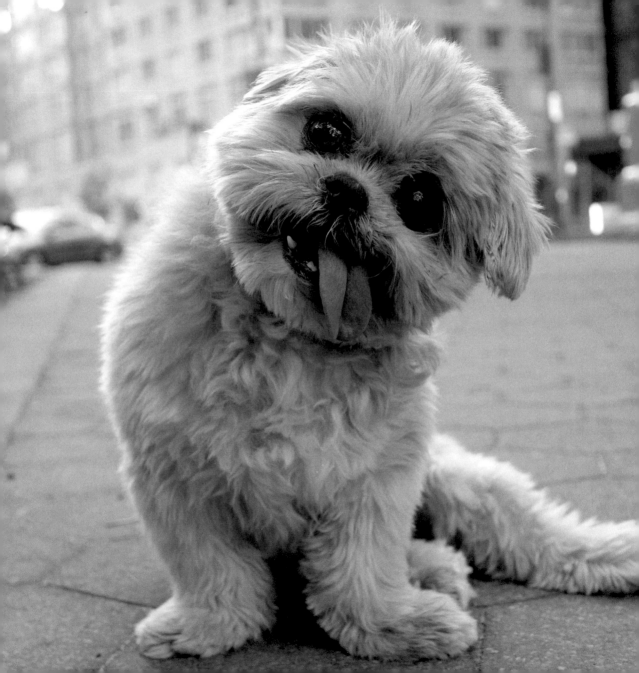

1 time I didn't have a home
and it was scary and I got sick.
Dont worry I am otay now.
This is me on the day I got adopted
from a shelter 3 years ago.

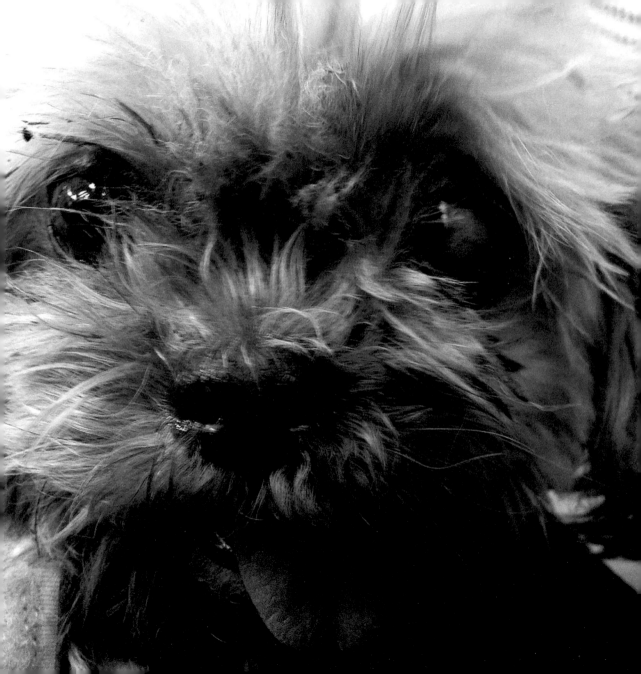

Now I have an apt
(that means a tiny house).
I'm also a book.
Here is my book.

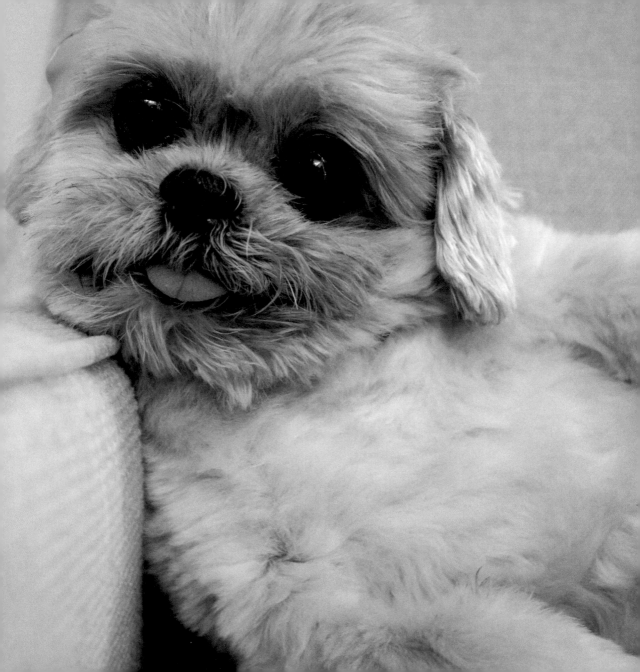

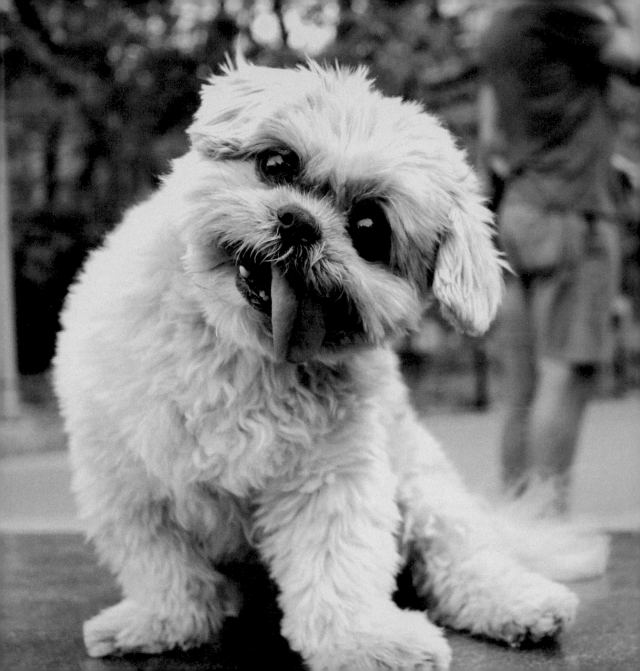

CHAPTER 1

THE GR8 OUTDOORS

Nature is on fleek haha.
That means its good.

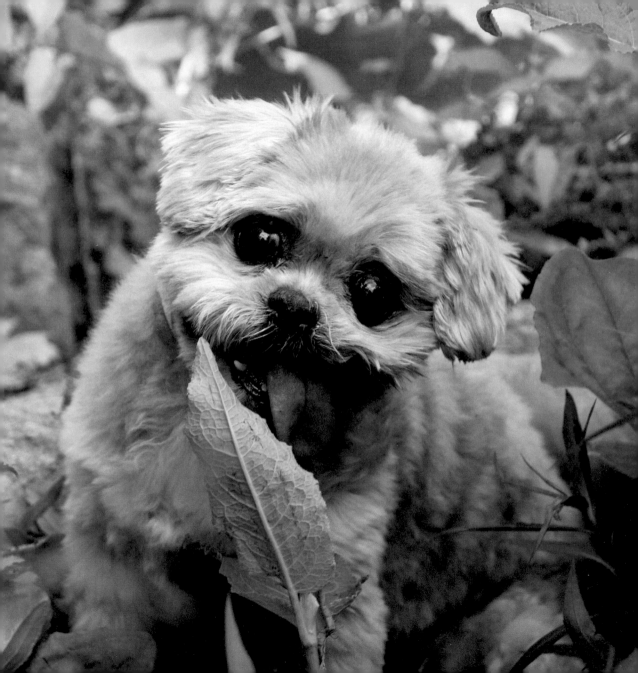

Going on an adventure brb

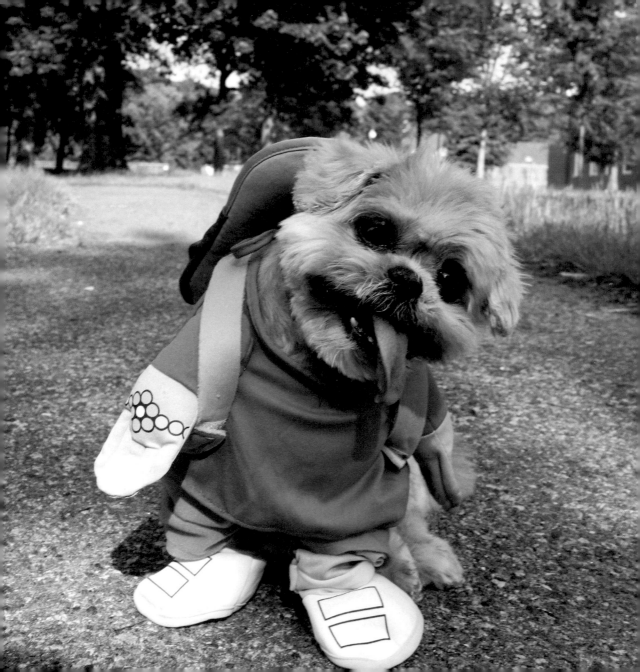

Gus is so tall

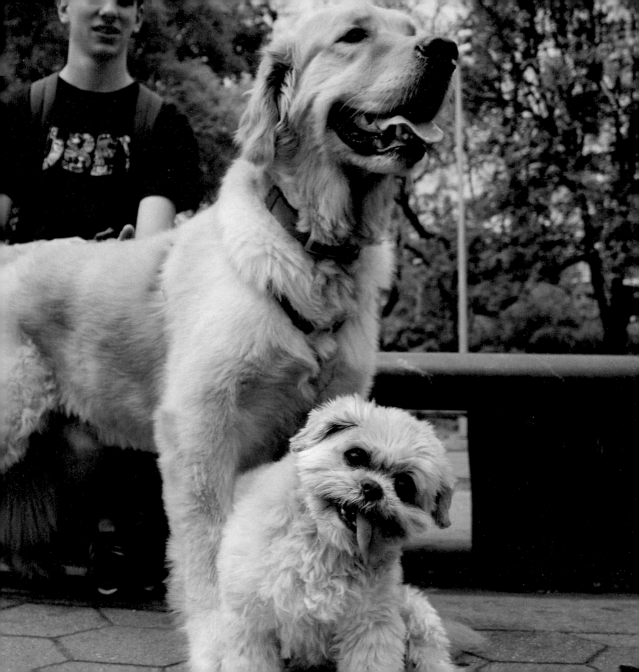

Welcome to my new house
jk lol

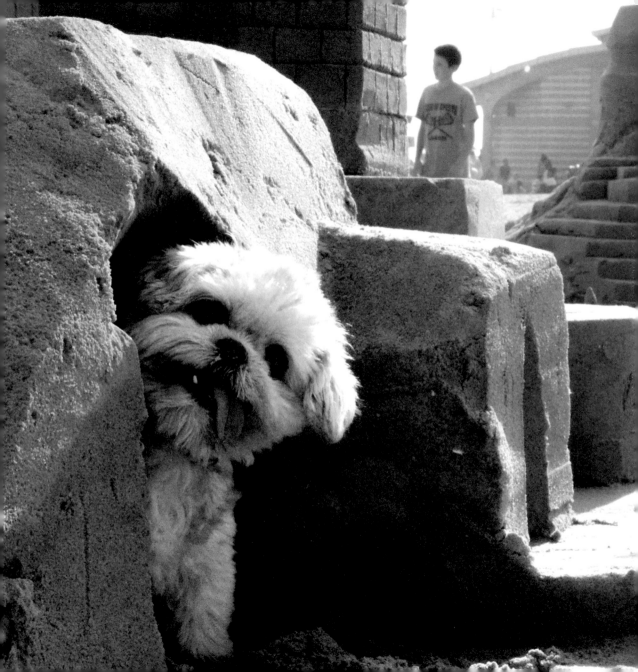

Have a good day
okay bi

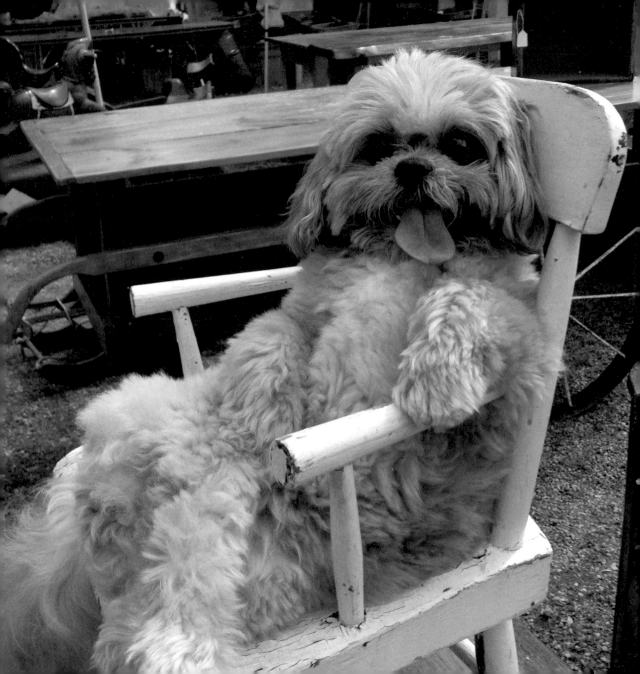

Relaxing by the swamp

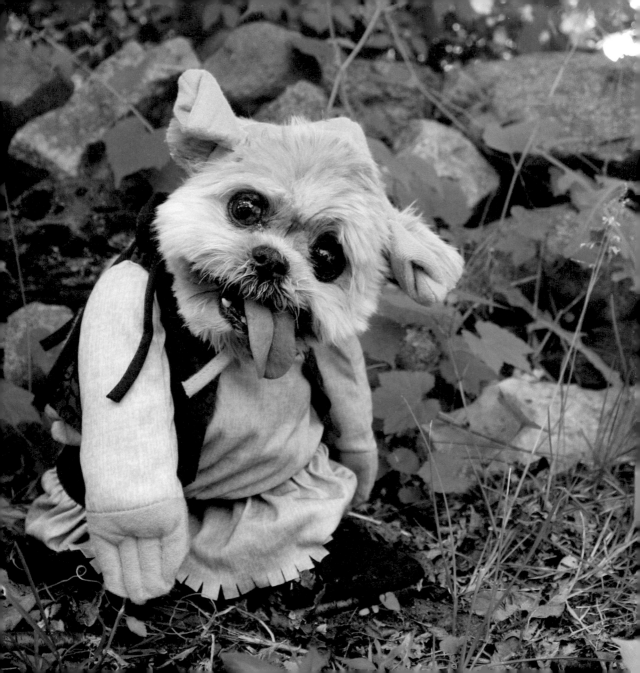

Finished my cardio

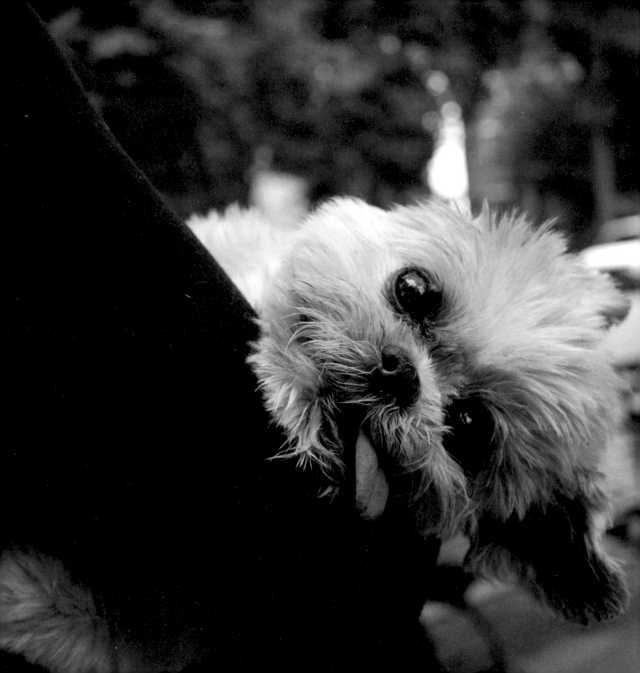

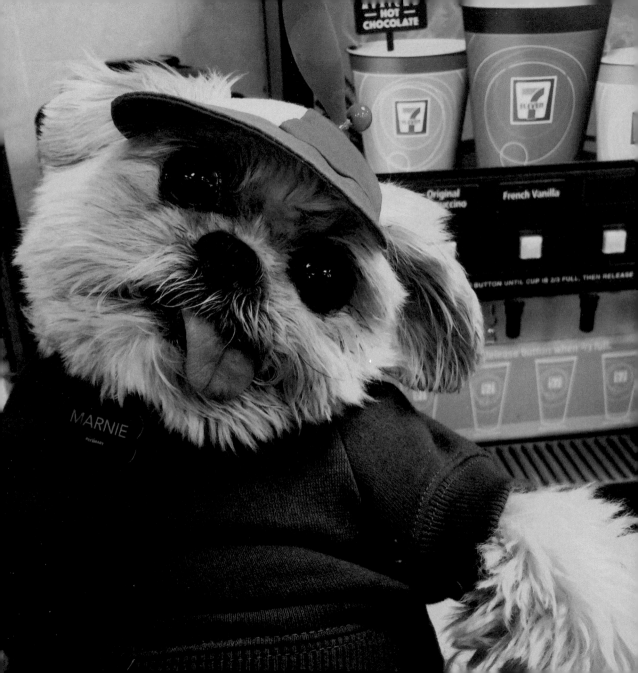

CHAPTER 2

WORK EXPERIENCE

Jobs?
I love jobs!

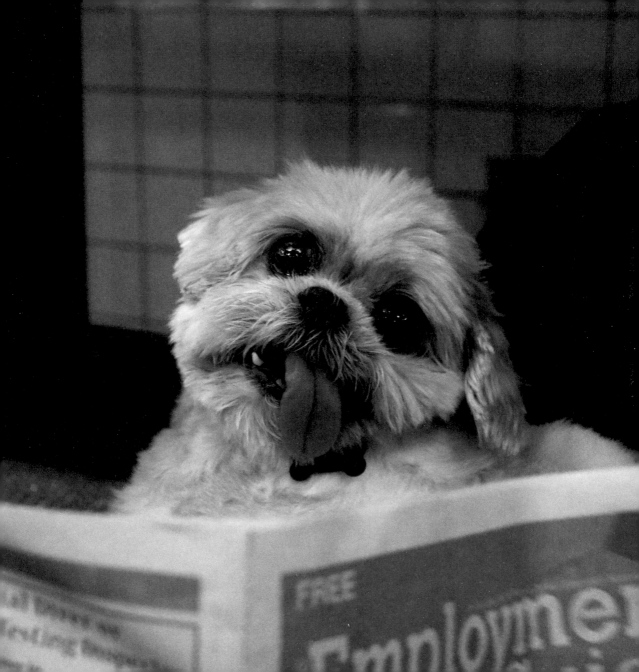

Respect my authoritah.
Haha lol.
Do u know that joke?

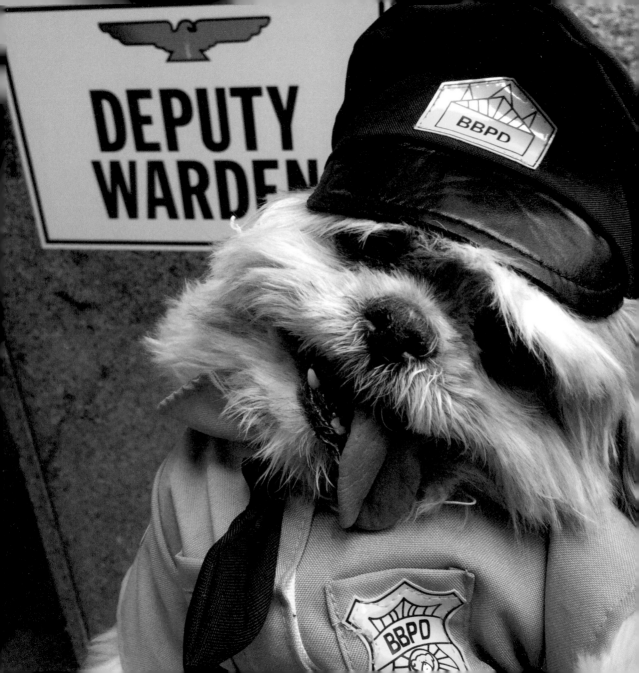

Yes we are gonna reform everything.
Otay next question

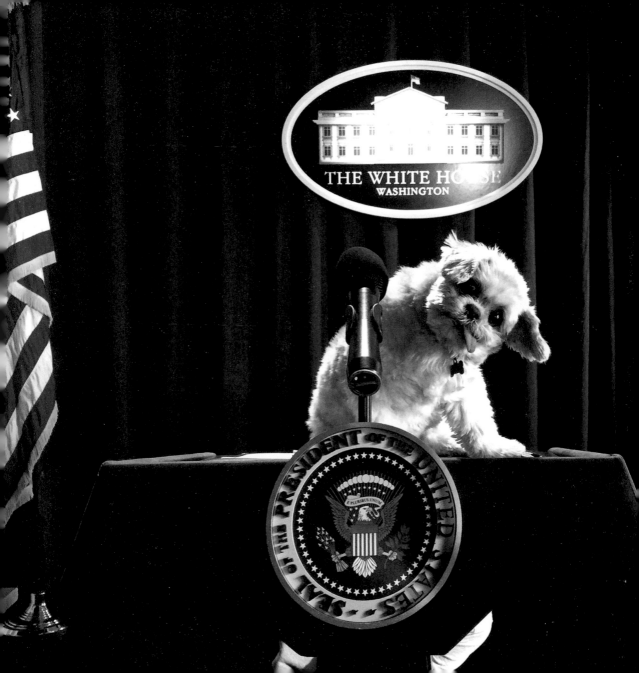

—

Maybe u can Google the
instructions 4 me

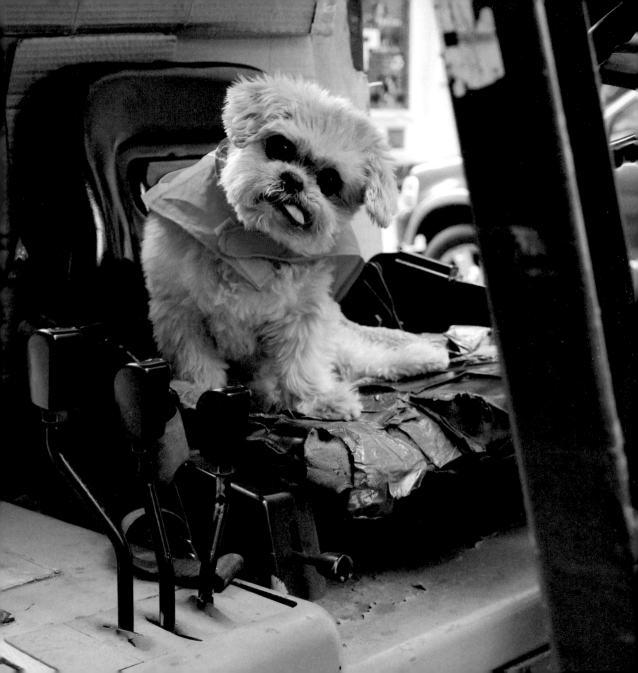

Where u headed?
Is there a party there?
Do u have a bae?
Whats ur nationality?
Who r u voting 4?

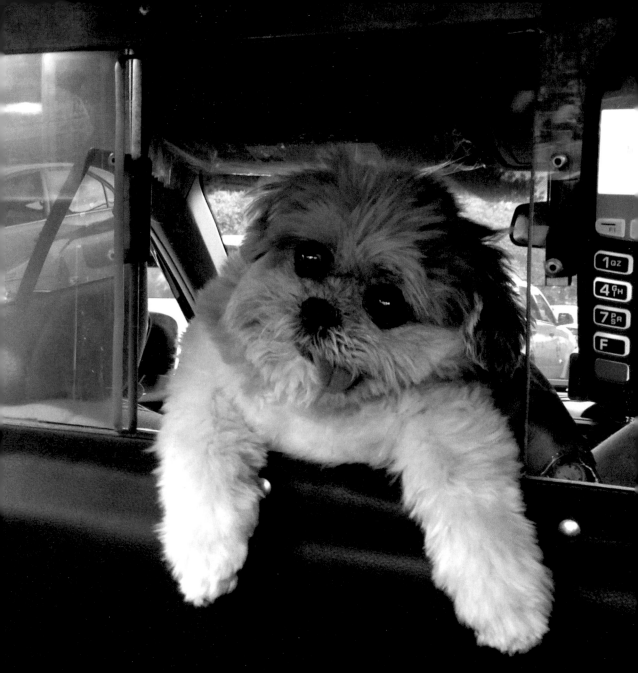

I'll save u
(that's not true so
pls make sure ur smoke
detectors work)

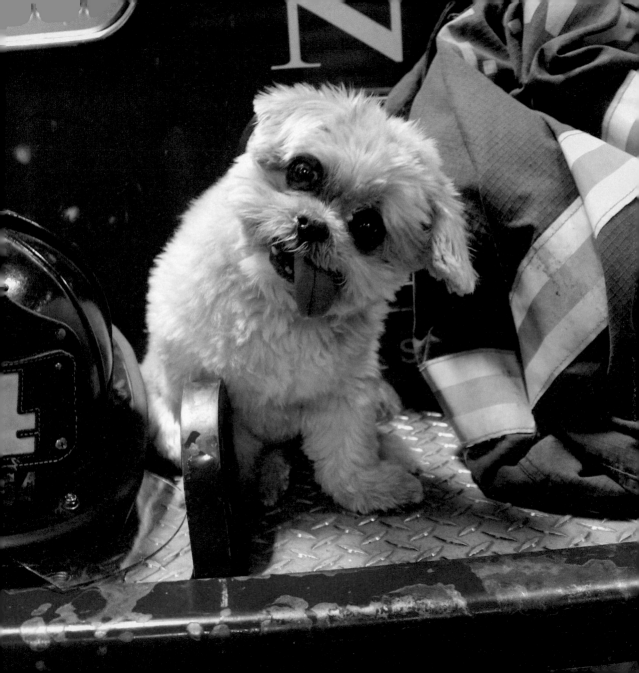

I can't tell u my real identity sorry.
Otay it's Marnie haha

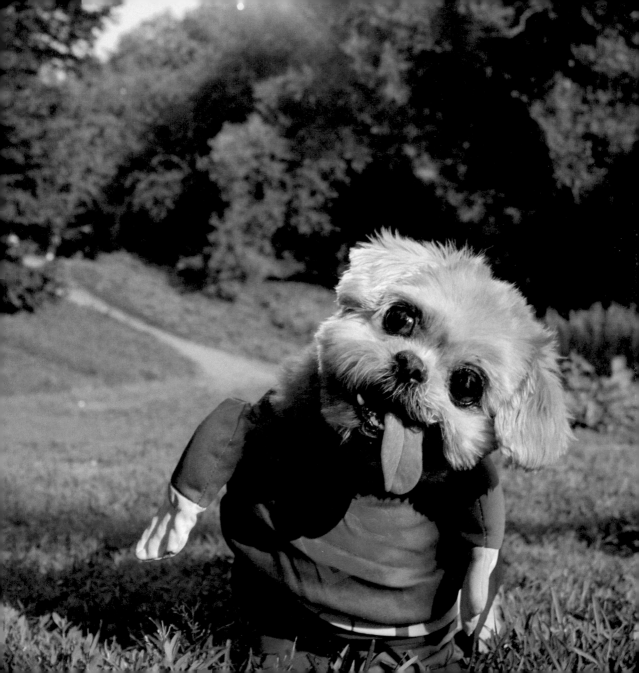

What snax should I give you?

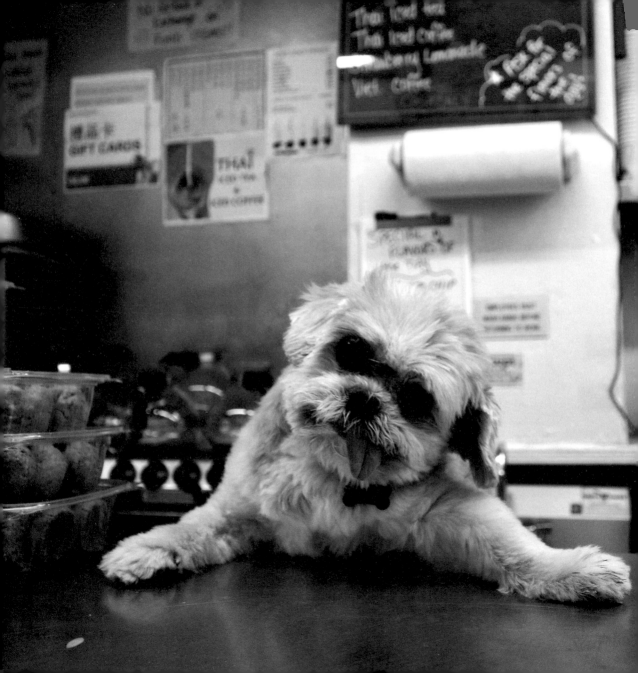

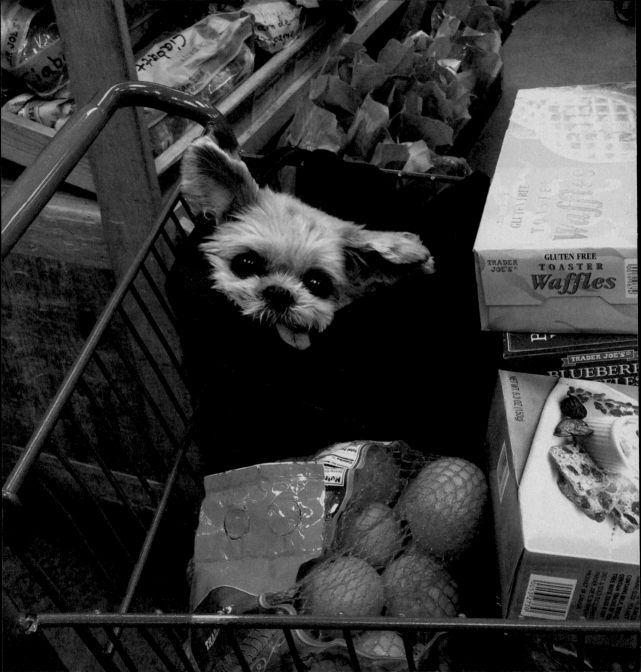

CHAPTER 3

THINGS THAT MOVE THAT I GO INTO

Wow I got shotgun,
I can't believe I'm so kewl

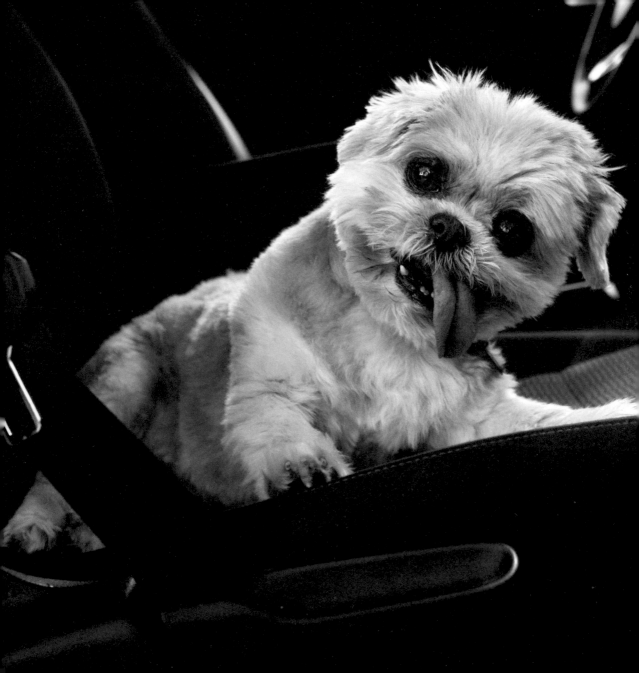

Exsqueeze me bike lane

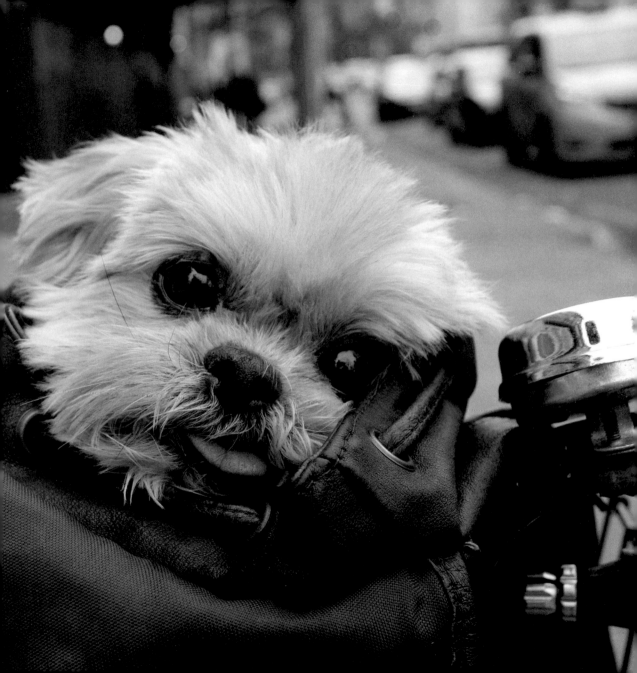

C U L8R

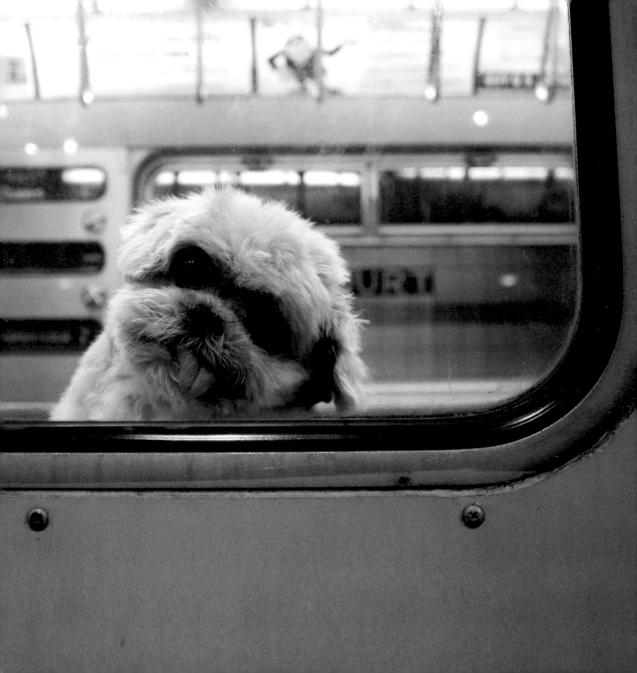

U can't manspread anymore
its the law

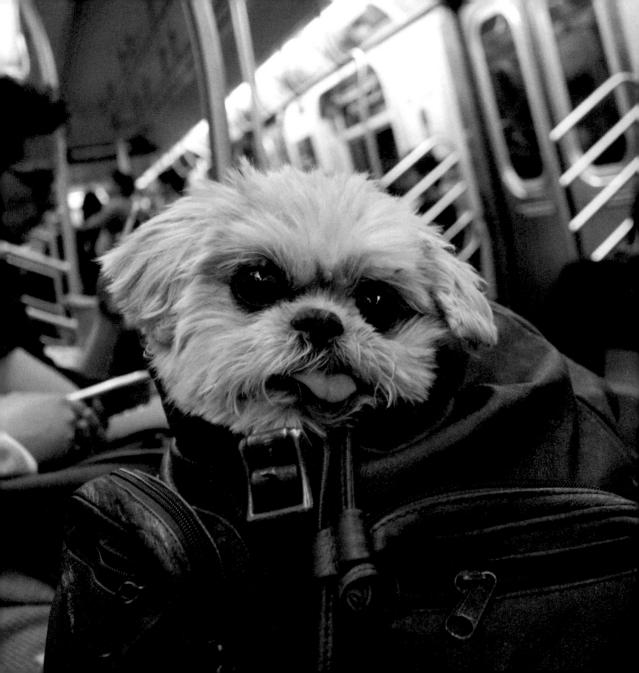

A free peanut?
Otay tank u

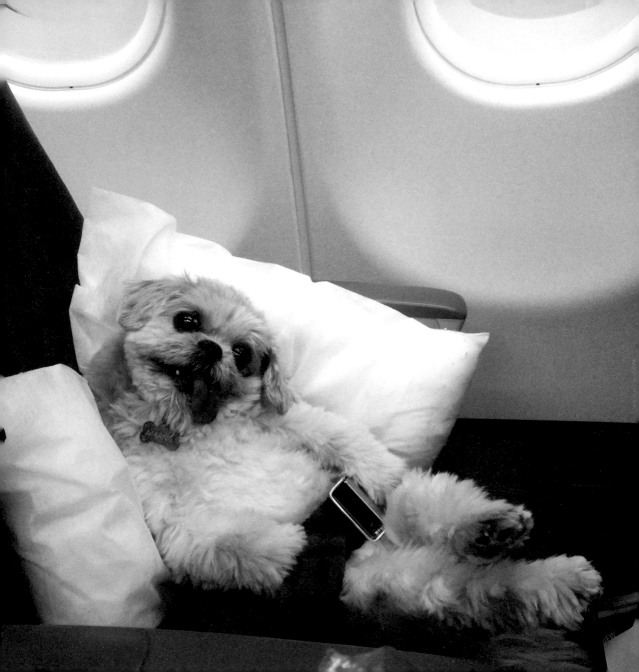

This bb has a turbo engine
with horsepowder
and a steering wheel yay

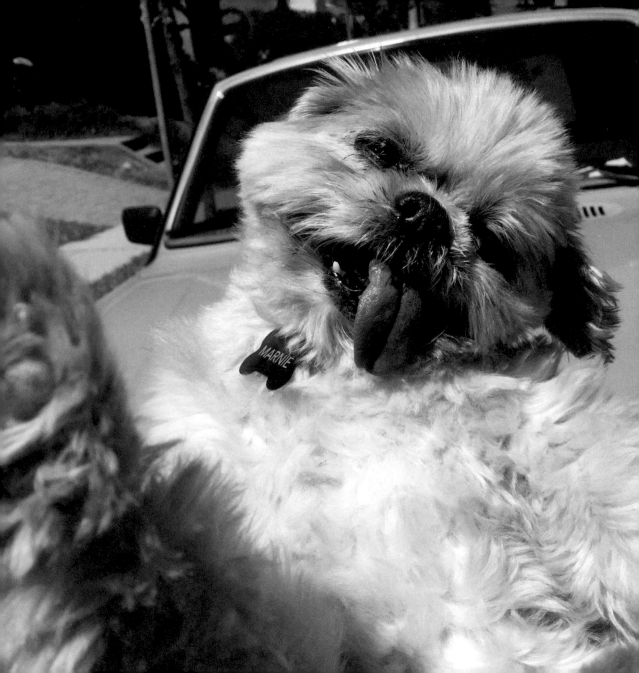

when I took the train
in the 90s #tbt

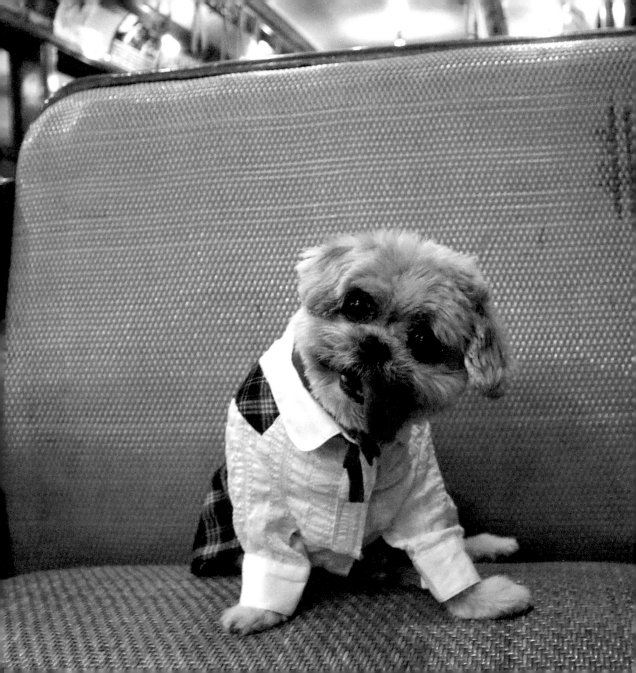

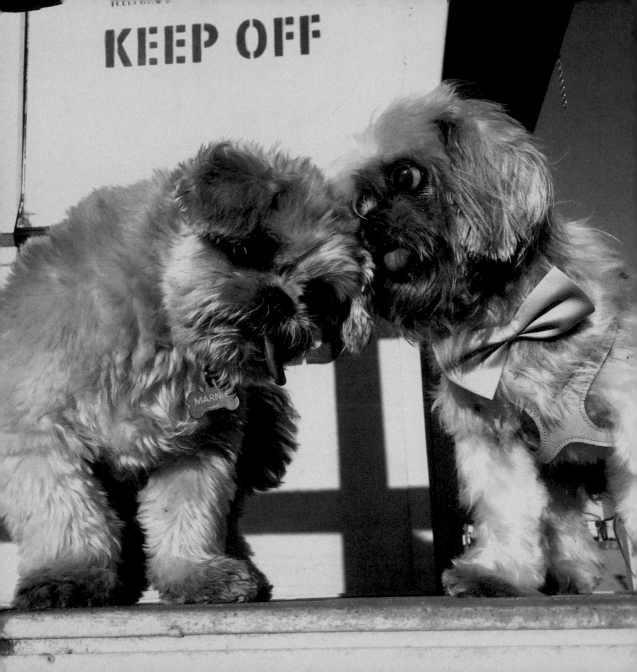

CHAPTER 4

HANGING OUT WITH OTHER PEOPLE WHO ARE ALSO DOGS

Me & Luna.
Hey Luna.

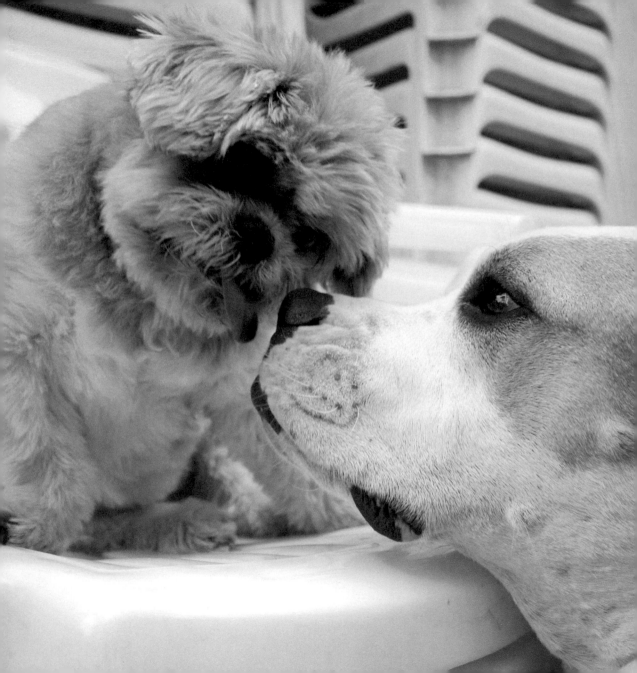

Me & Hammy.
His real name is Hamilton.

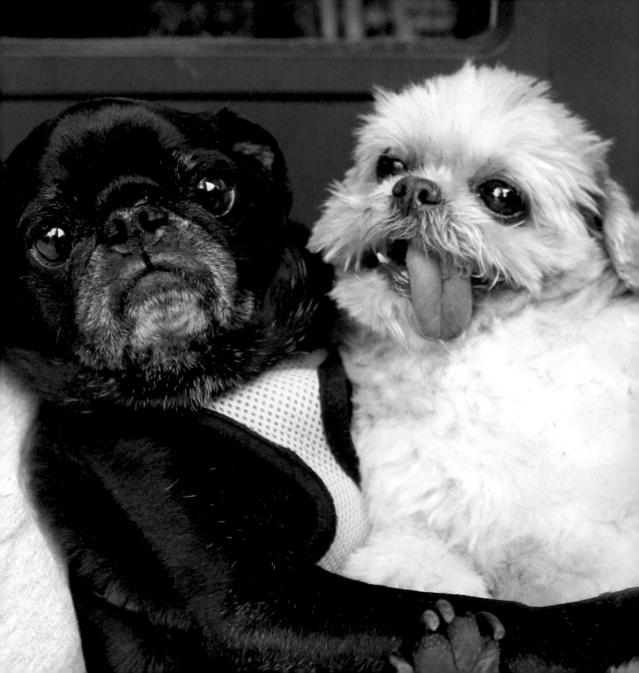

I don't even know this guy

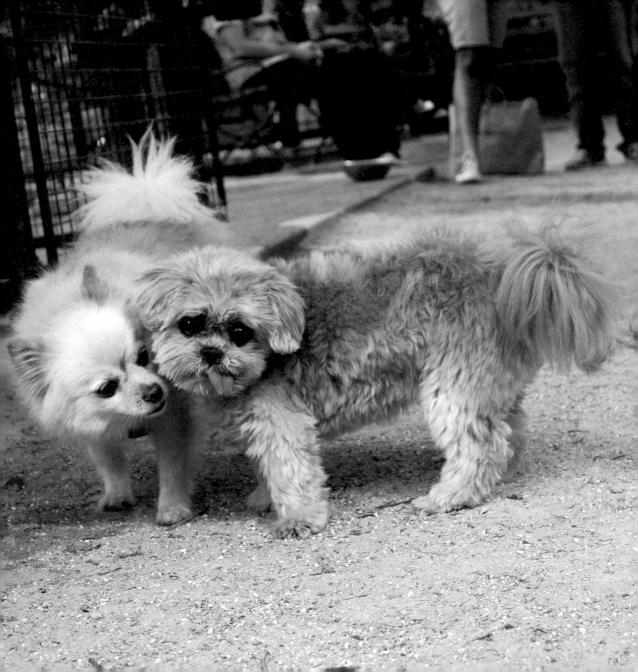

Wait a minute Smokey da Lamb,
u not a dog

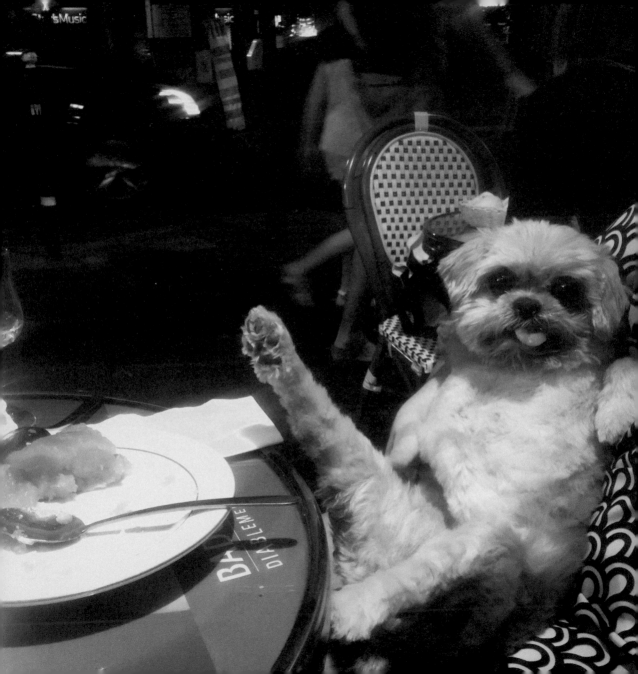

CHAPTER 5

SNAX 4
MARN MARN

I'll have what she's having.
That's a joke from a movie.

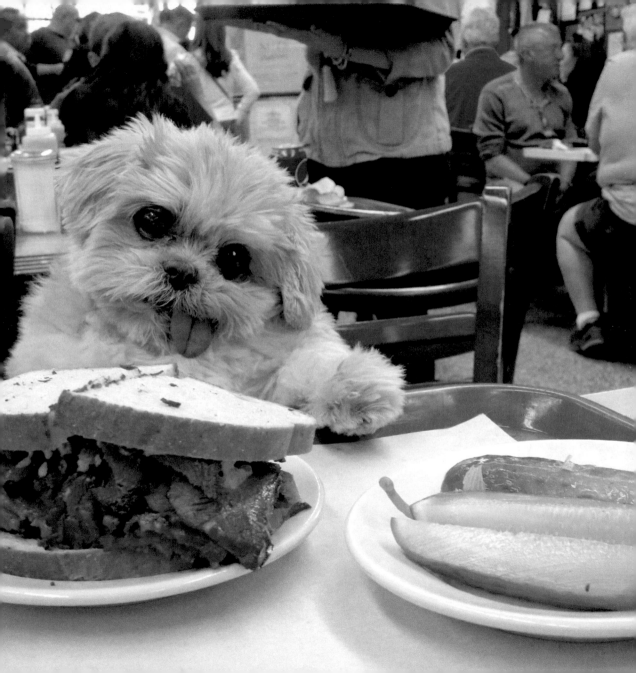

These noodles r so long amirite?

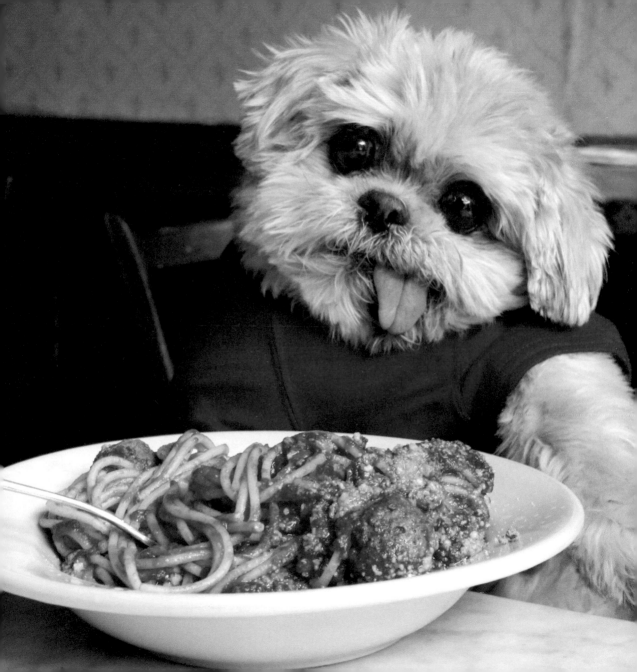

Having drinks with Beanz

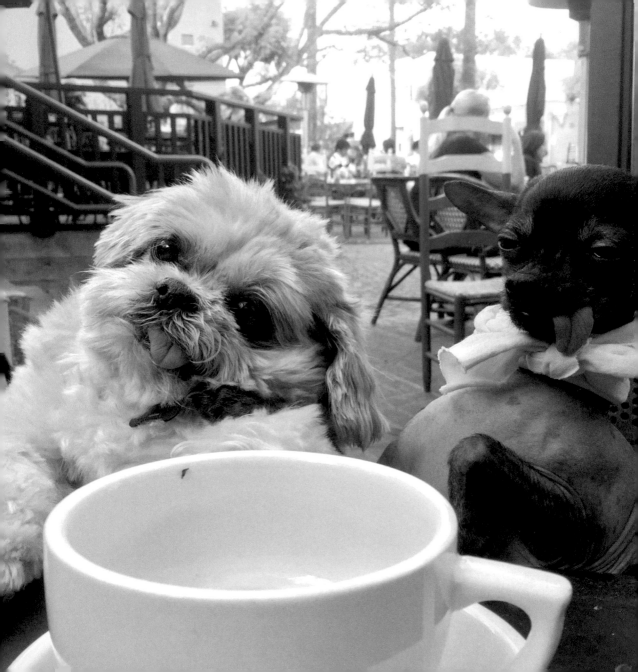

Candid breakfast shot

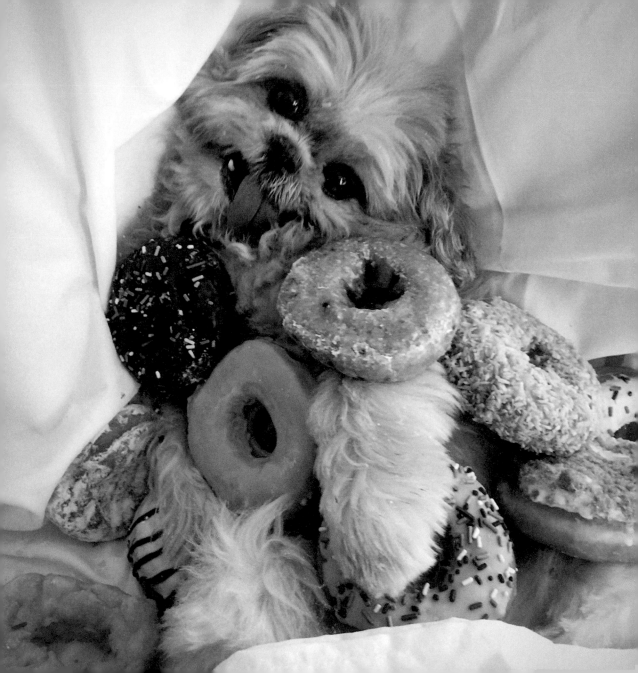

Sweetish Meatballs

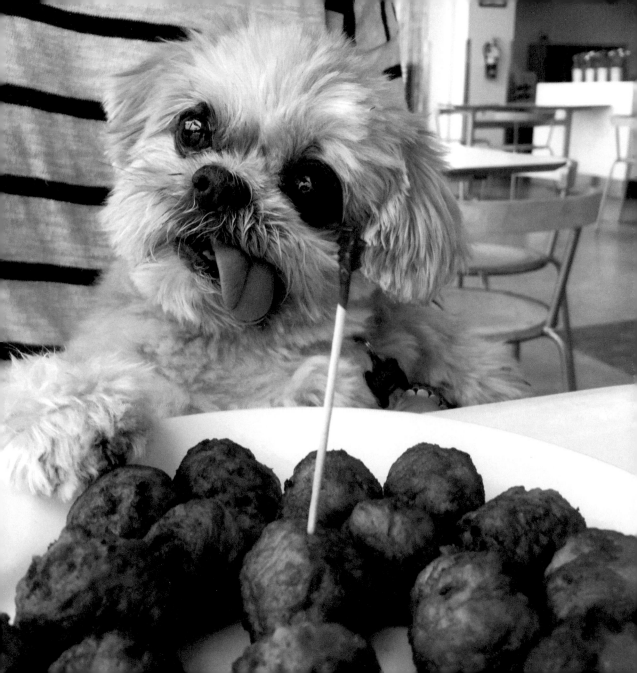

Sometimes I put bread
on my head cause its weird
but in a cool way

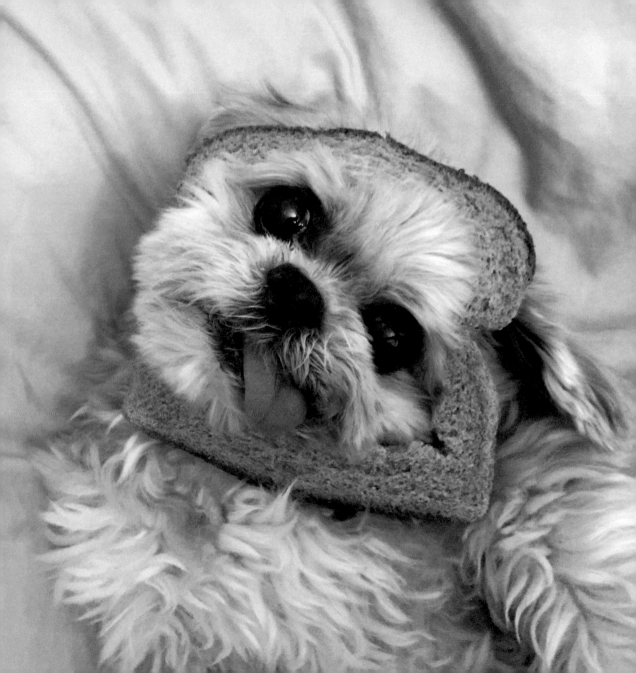

CHAPTER 6

SPECIAL DAYS

OMG I'm so smart now yay

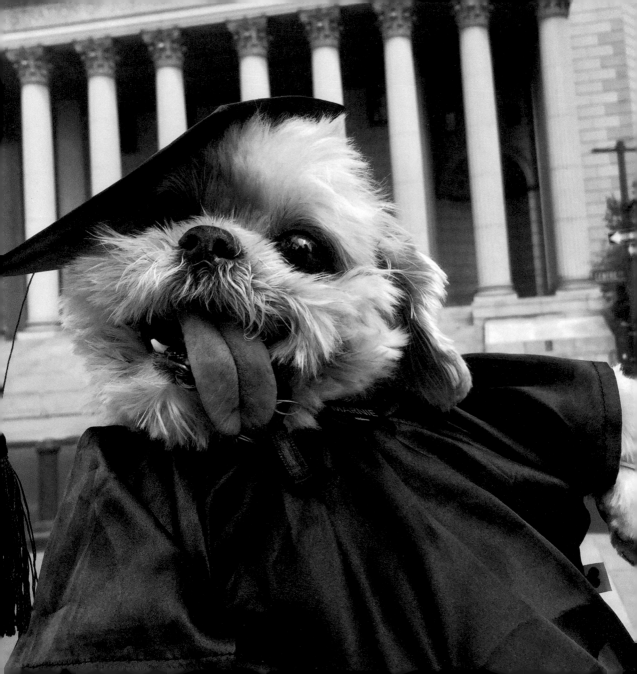

BRB have 2 spread cheer

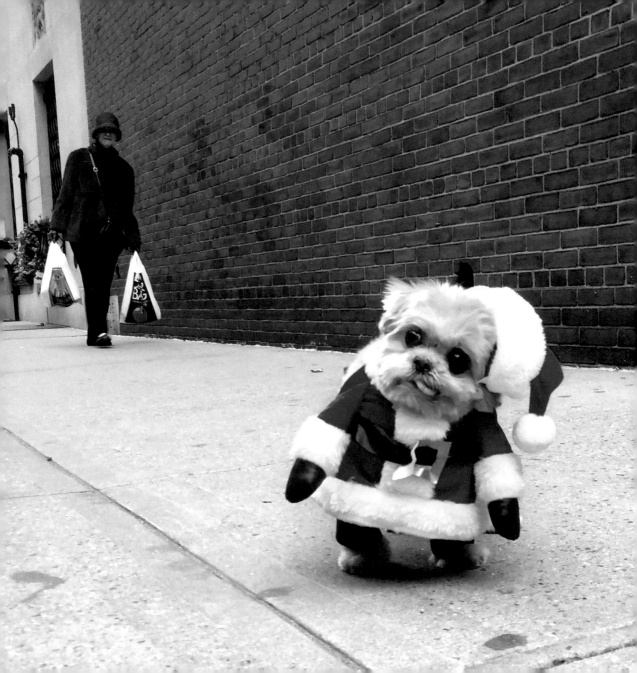

D-g Bless Murica

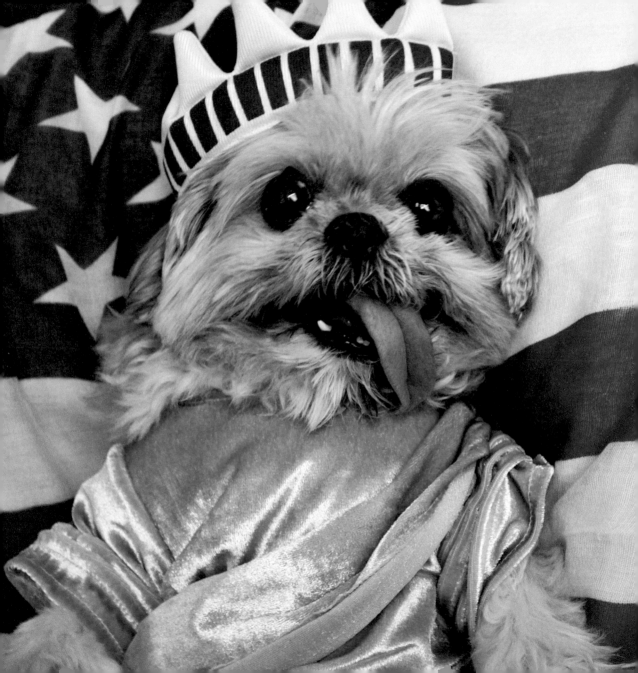

This is so romantic

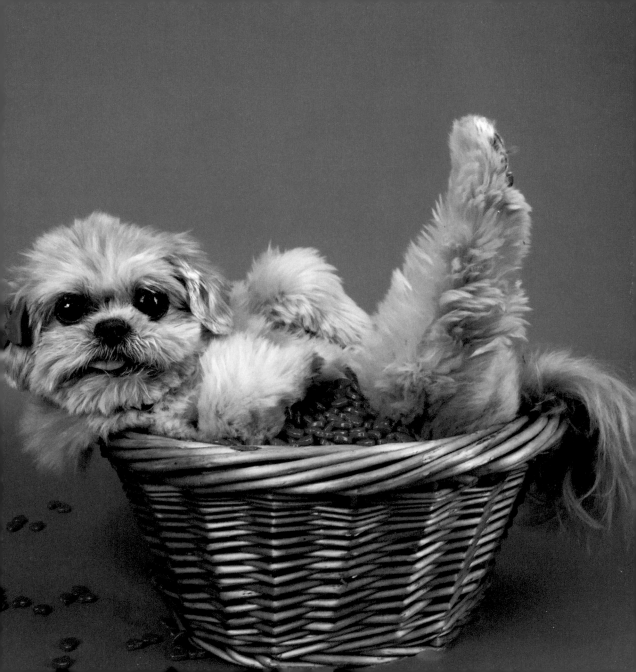

No I'm not Marnie.
Who dat?
Haha Fooled you

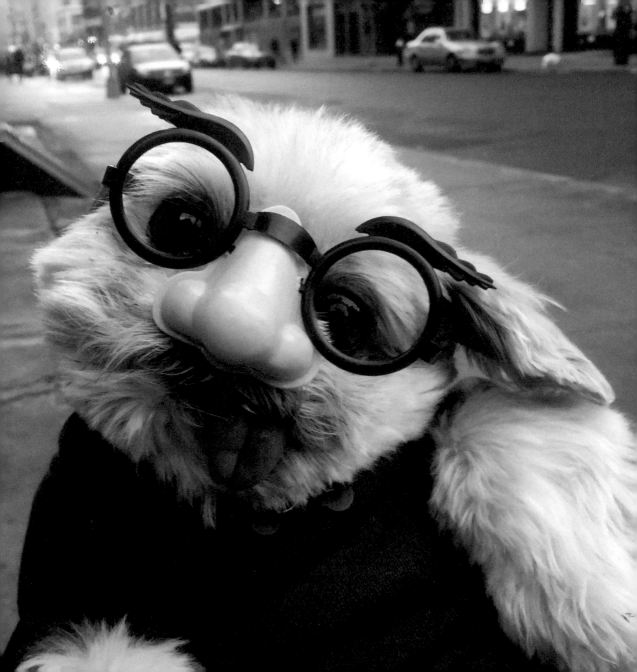

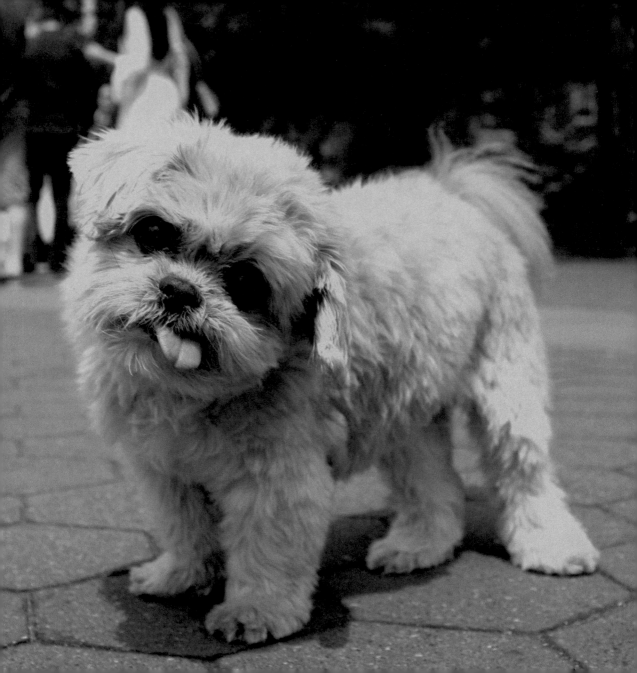

CHAPTER 7

IN MY HOOD (THAT MEANS NEIGHBORHOOD)

Chillin by the pier

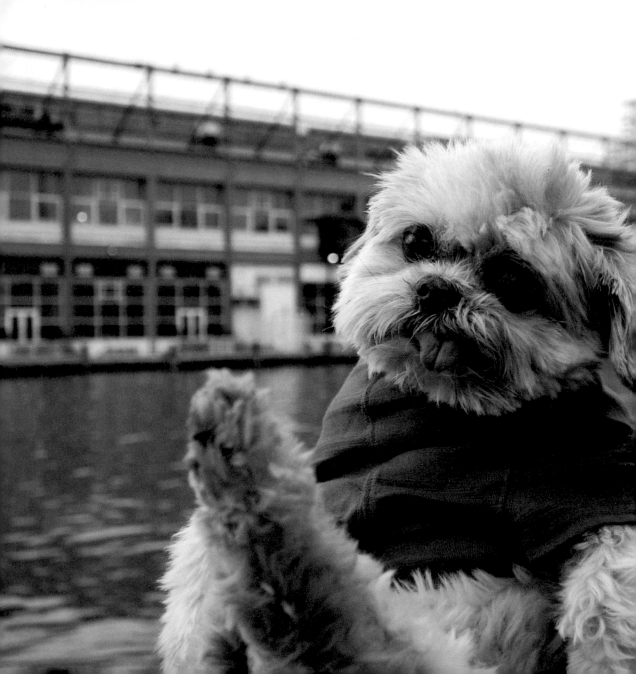

Where's Marnie?
Try 2 find me. Keep looking.

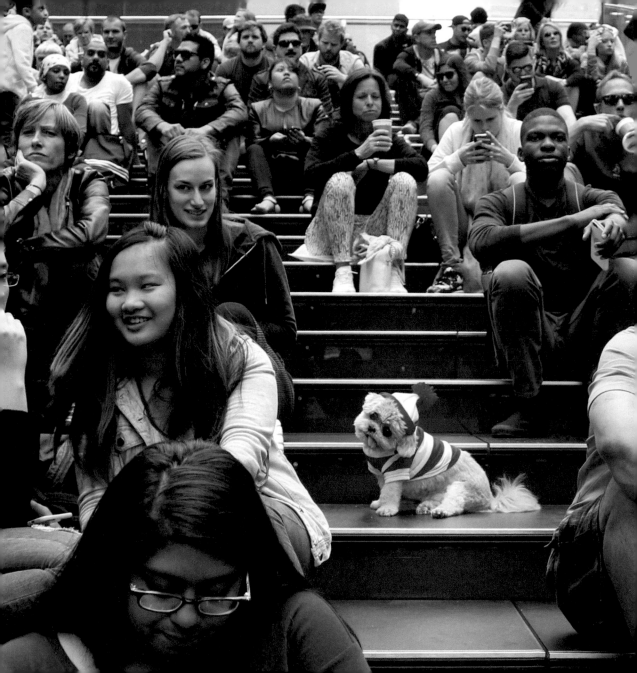

I just called 2 say
I love u

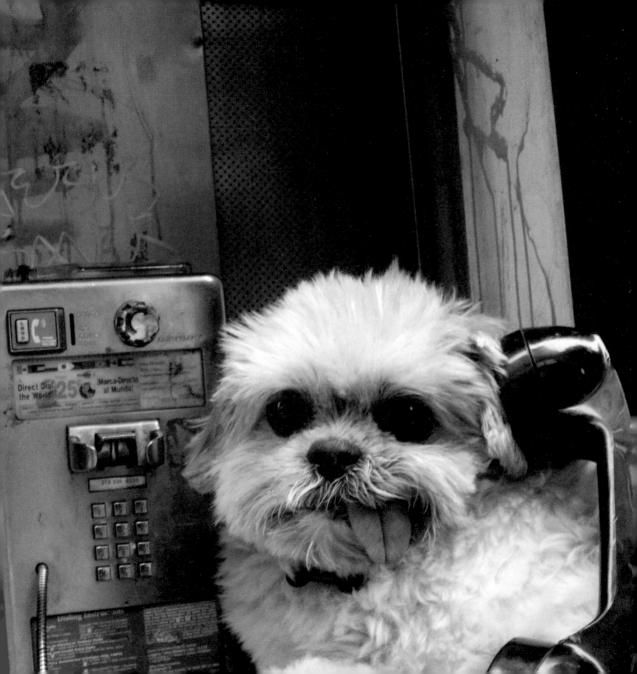

Spending time w Simon

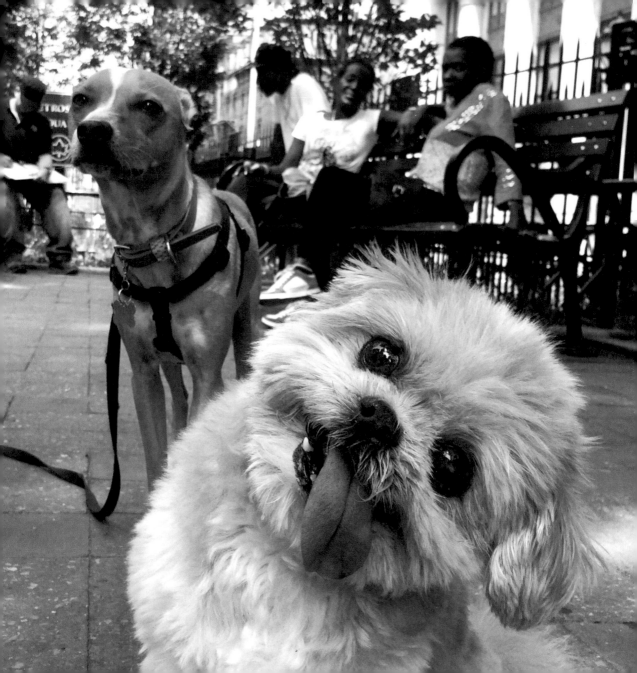

I hope it don't rain
bc then I get wet

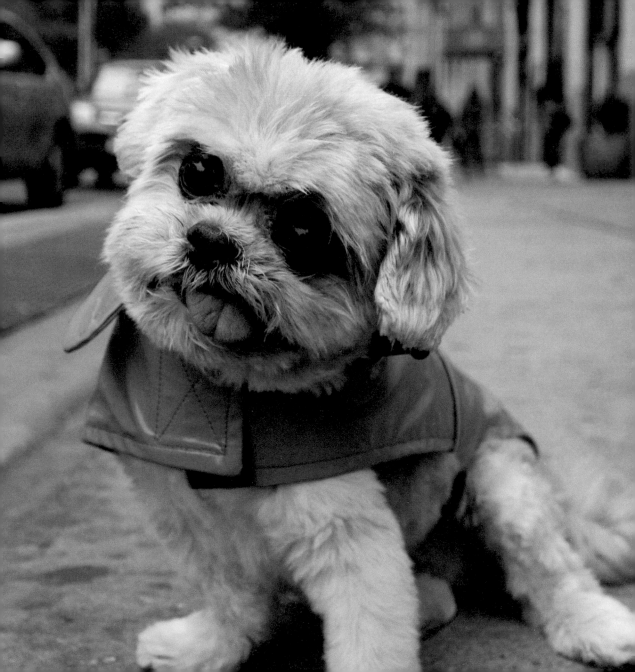

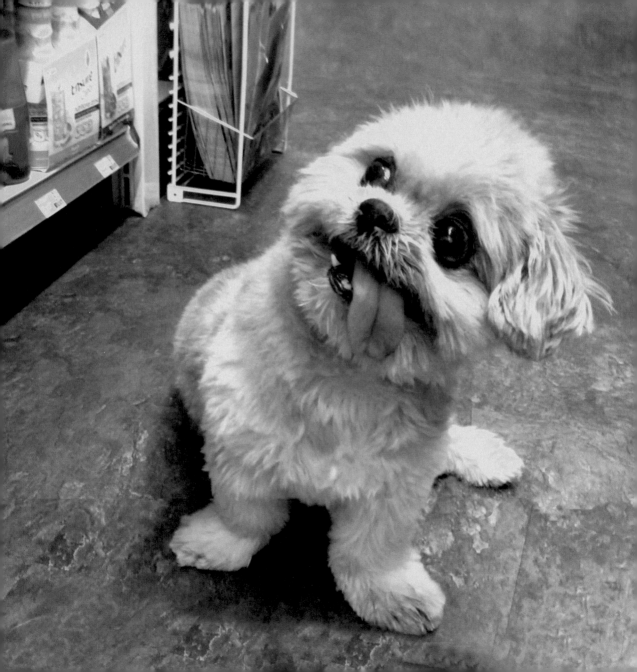

CHAPTER 8

STIMULATING THE ECONOMY

Hold on I gotta get cash

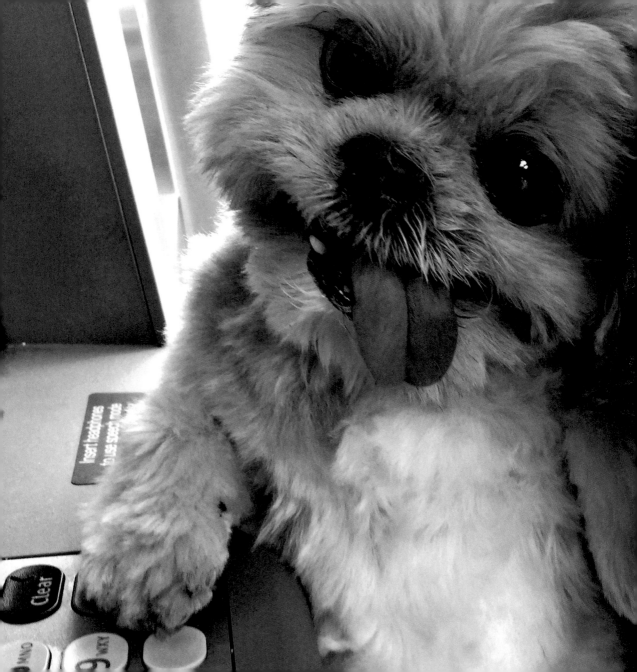

Waiting 4 bae at the mall

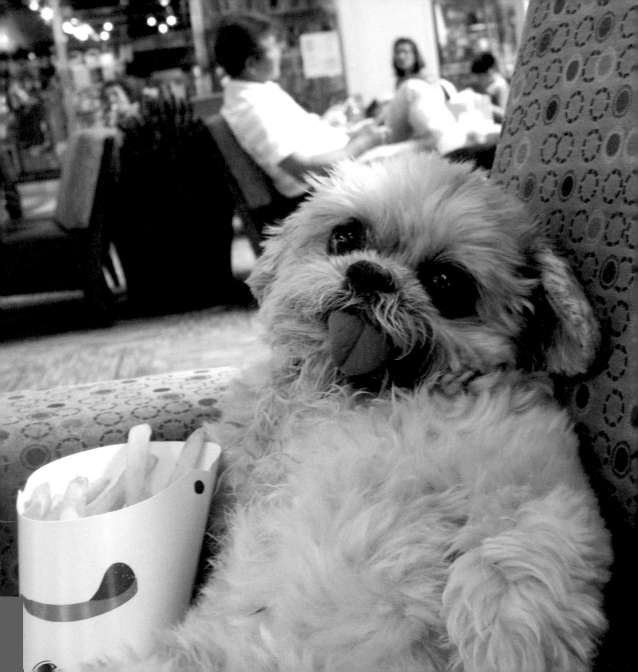

I hope they have my size

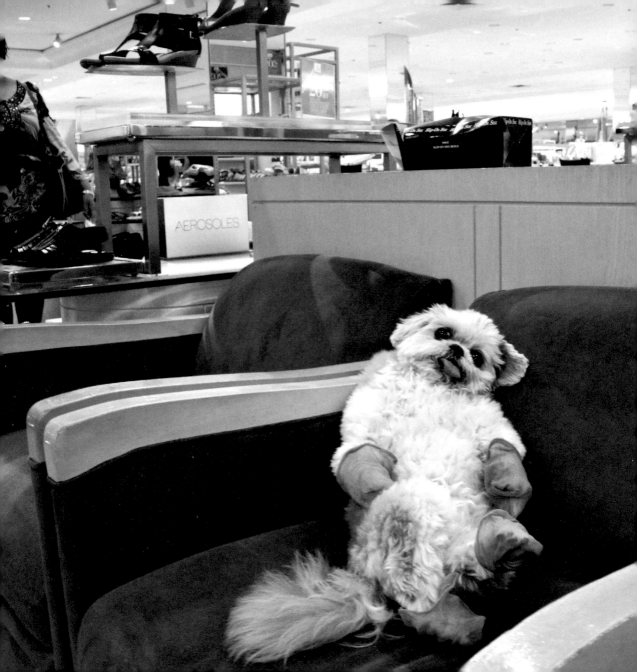

Is these ones the rite
shape 4 my face?

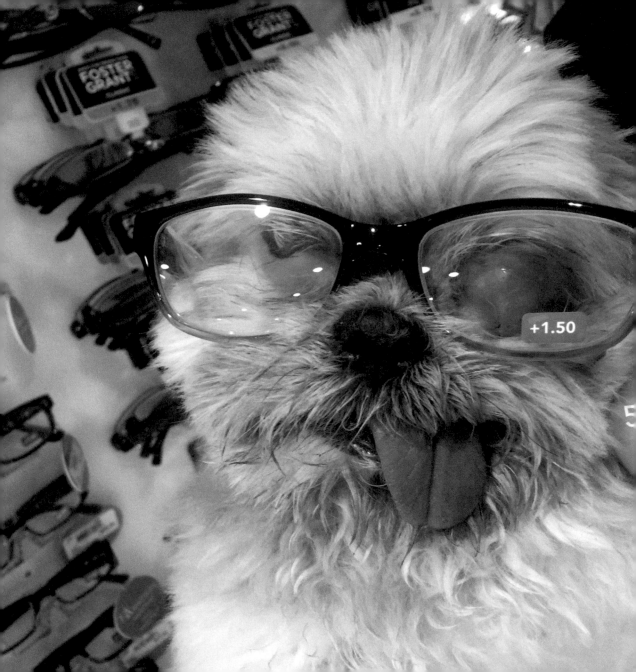

Getting ready 4 da club

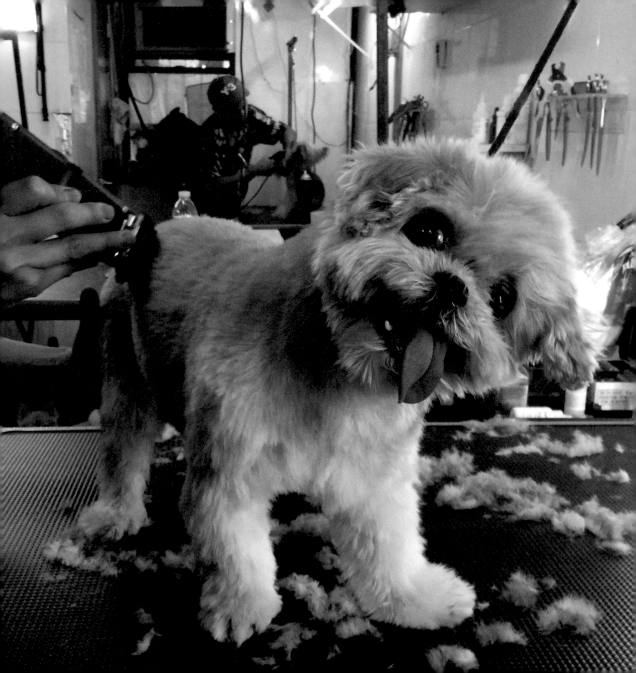

At the museum 4 culture

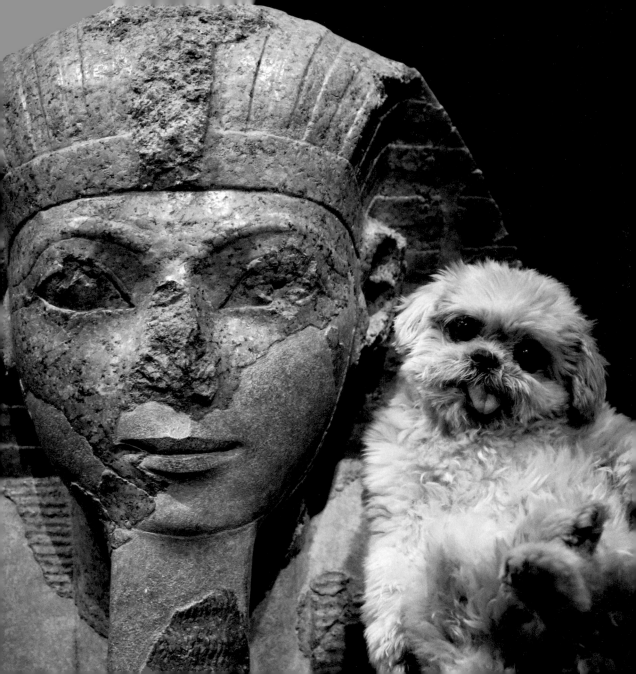

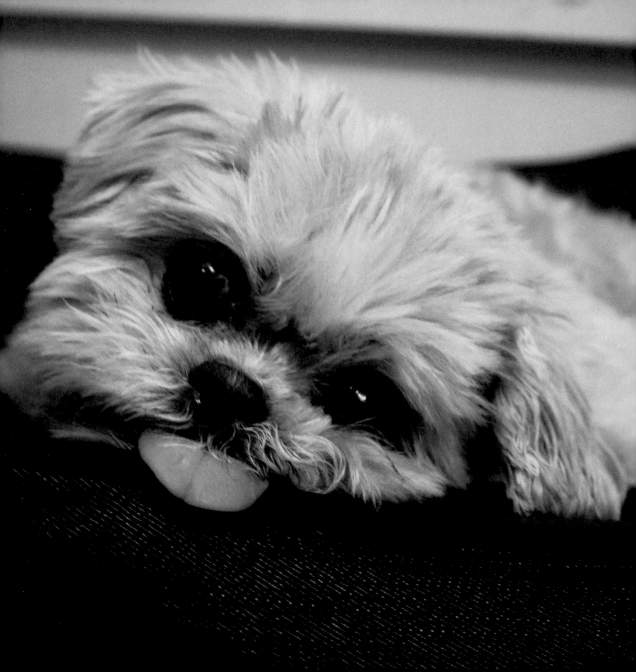

CHAPTER 9

DOMESTIC GODDESS

That feeling when ur not on
the bed but u want 2 b

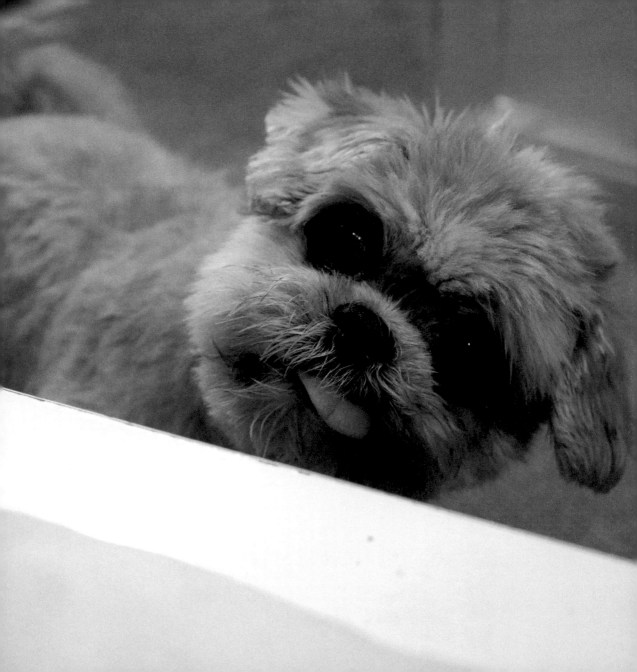

Relaxing in the kitchenette
(that means tiny kitchen)

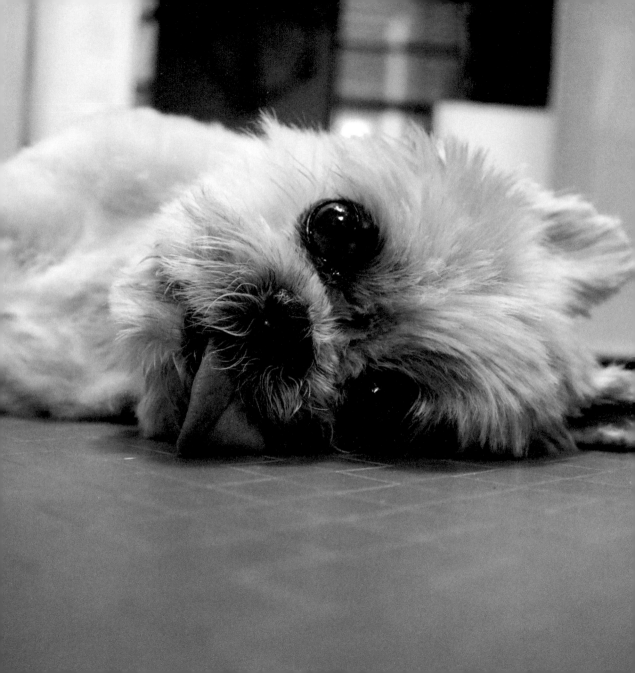

sleepover at my friends house

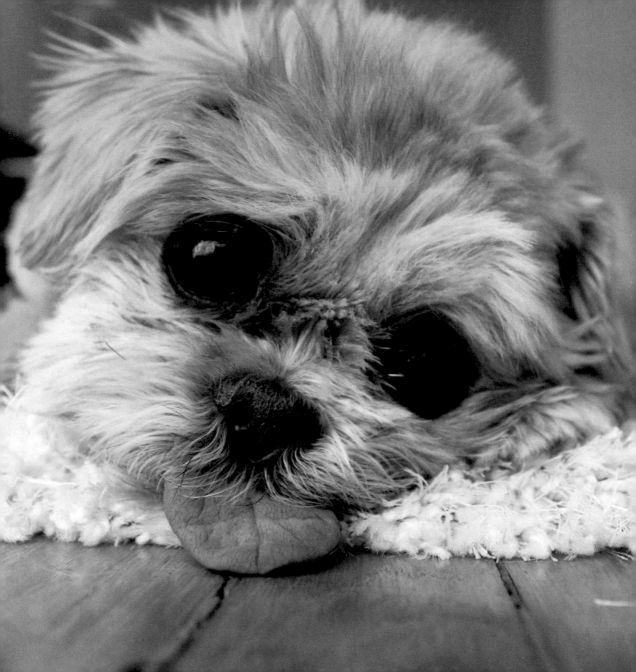

Pajammied down & ready 2 sleep.
Tank u 4 reading my book.
I hope u learned a lot bi.

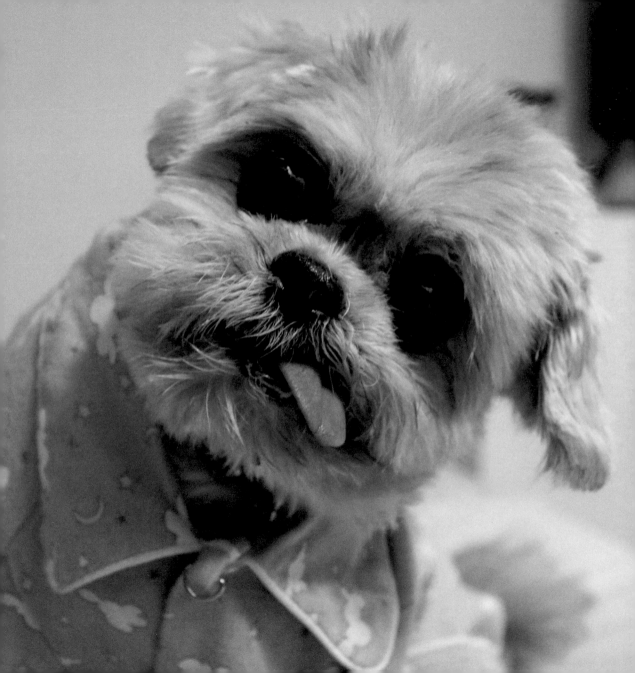

ABOUT THE AUTHOR

Shirley Braha is bae and personal assistant to Marnie the Dog, who she adopted from a shelter in 2012. A graduate of Smith College, she has taken an indefinite break from her career as a music television producer to hang out with her dog. They reside together in New York City.